THE WILD IN YOU

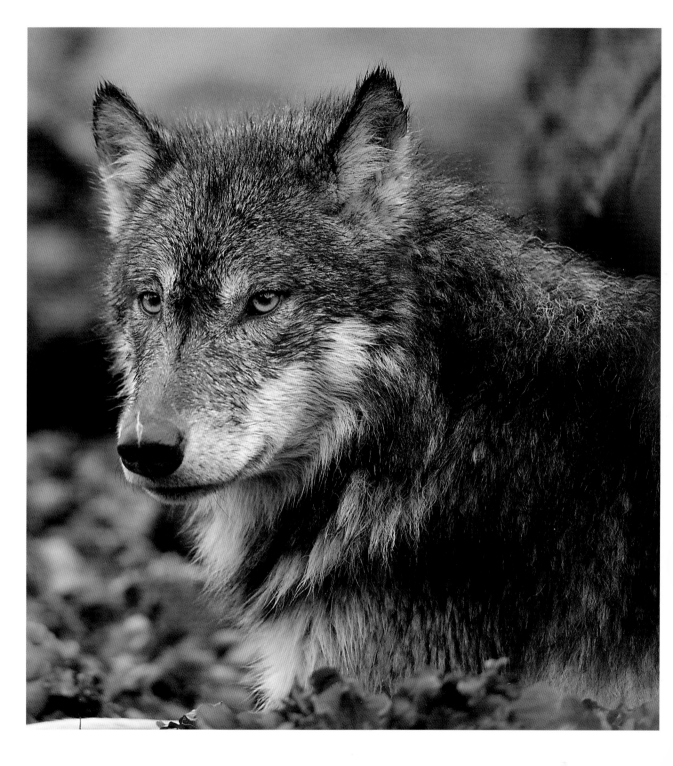

TEXT BY **LORNA CROZIER**
PHOTOGRAPHS BY **IAN MCALLISTER**

VOICES FROM THE FOREST AND THE SEA

THE WILD IN YOU

GREYSTONE BOOKS
VANCOUVER/BERKELEY

Introduction

Grizzly hunches by the berry bushes on the other side of the estuary, so close he can hear the rain pound on my jacket. My rubber boots slip on the rotting bodies of salmon tossed from the water by claws uniquely curved to grip a fish thrashing against the current.

This is the heart of the rainforest but it's also a charnel house without walls or ceiling, the stench of decay brushing my face like the wings of mortuary moths. Gulls scream and dive with remarkable precision into the spawning beds. Their beaks pluck a single orange salmon egg, no bigger than a pea. The return of the salmon to the rivers of their birth, the new life spilling from the mothers' torn bodies, is one of the most poignant of the earth's miracles.

The grizzly raises his blunt head and courses the air. Stares at me and sniffs. He is huge. Above the reek of fish, my smell is drawn into his body through the nasal passages in his long snout. Part of me now lives inside the mind of an omnivorous animal whose Latin name ends with *horribilis*.

I know in my gut, in the place where you know the deepest things, that I am changed. On the far west coast of North America, I'm vulnerable and naked, though I'm clad from head to foot in rain gear. I struggle to name what I'm feeling. It's like trying to label that spot on the back of the neck where fine, invisible hairs, sensitive to fear and exaltation, rise. Suddenly, I get it—I'm wilder, yes *wilder*, than I was before.

Drenched and cold, I squat above the ragged salmon, keeping my distance, but eye to eye with my first grizzly bear. I hold onto this sensation as if I'm gripping it with long sharp claws. For a moment, what keeps the spirit in the body and what separates one species from another disappears. I have moved outside my skin into a state of sweet connection. Attentive, nameless, quieter than the rain, I see the bear and the bear sees me. What is untamed and unafraid has reached out from me to meet the largest land mammal on the continent. "The brain is wider than the sky," Emily Dickinson wrote. Our brains, human and bear, touch each other.

To be silent at such a time is proper; it's part of being in a state of grace. But because I've lived most of my life as a writer, I'm obsessed with trying to find words that will hold my wonder, however clumsily, and pass it on. Like the best of photographers, poets strive to translate what the eye sees, but also what the soul catches and holds up to its own uncanny light.

Ian McAllister is such a photographer: he knows that inner shine. It illuminates his photographs of the Great Bear Rainforest, that sweeping track of coastline that flows from the tip of Vancouver Island to the Alaska Panhandle. He and his wife Karen have known this traditional First Nations territory intimately for over twenty years. It's their home. Their life work is to protect it.

My stay in the Great Bear lasted only five stormy days one October. Kim Gray, the editor of the online magazine *Toque & Canoe*, sent me there to write a travel article and she set up a meeting between me and her

friend Ian. She thought we'd like each other, she said, and he'd agreed to take some pictures while I was there. Knowing the brilliance of his photographs and his international reputation, I didn't expect to meet such a modest and laconic man.

A chewed-up wool toque pulled low on his forehead, his face reddened from the ocean and the wind, he hopped out of his boat onto the dock, held out his hand, and—Kim was right—I liked him instantly. She'd also said, with naïve optimism, that maybe Ian and I could do a book together. We both circled that suggestion like strange wolves and promised each other nothing. Yet by the time I left, we'd agreed he would send me some photographs and I'd see if they triggered a response. He doesn't need poems to enhance his images—they don't require any explanation. My challenge was to make a new thing that could stand beside each picture and speak to it in an unpredictable, hopefully surprising, way.

It wasn't only the days I spent in the rainforest and Ian's photographs, brilliant as they are, that turned me to poetry. It was also learning about the vulnerability of this place and its inhabitants. I share Ian's passion for the natural world, and though it may sound crazy, I believe that if we honor living things other than ourselves—orcas, ravens, wolves, cedars— our attention will remind us that they are holy. To see them clearly is the deepest kind of praise, the deepest kind of love. To wound them and their habitats is to wound ourselves.

As I move toward seven decades of living on this earth, I find myself growing lonelier. It's not the deaths of friends and members of my family that make me feel forlorn, though those losses bring a grief that numbs.

It's the loneliness that comes from the wiping out of songbirds, salmon runs, and old-growth forests. It comes from trophy bear hunting, where men with rifles walk with a bear's head and paws past the Coast Salish signs banning such gruesome acts in their homeland. It comes from over-fishing, fish farms and feed lots, from hydro dams that flood a valley full of life, from tailing pond spills, from sulfur spewing out of smoke stacks, and the likely deluge of bitumen into the waters of the largest intact rain-forest in the world. Soon there will be almost nothing left but us, the most destructive species ever known. The damage we cause is eating us alive, no matter what our jobs, our age, no matter where we make our homes.

The Great Bear Rainforest is the route for Northern Gateway. On a map you can trace a line where oil tankers will travel its waters, famous for storms and rough passages, to get to Asia. Imagine the salmon, whales, otters, and anemones blackened by bitumen. Imagine what will happen all along the shoreline to the wolves, eagles, ravens, trees, and people whose ancestors have lived in this pristine wilderness for thousands of years. It's overwhelming to think of the devastation, but it's more over-whelming to feel defeated and do nothing to stop it.

May these poems and photographs stand as testaments to the mirac-ulous beings that share our planet and to the habitats that are necessary to their and our survival. We are not more valuable than they, not more special in the sun's eye and the moon's. We offer this book without false hope and without despair as a stay against the harm we cause. May these images move from the heart of the rainforest to the heart of you, from the wild in us to the wild in you, wherever you may be.

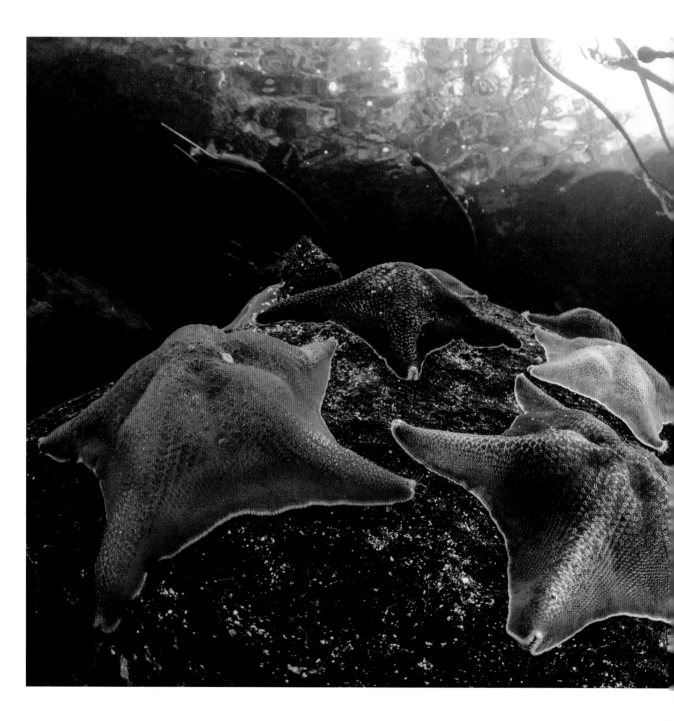

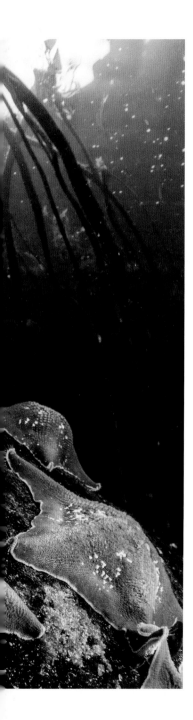

Water

Cliffs along the estuary,
dry an hour before, are striped
with long white threads
as if a spider spinning a water web
drops a string from the top
to the sea below, then scurries up,
drops another line and one again.
Steeped in rain, bats take on
colors like a sea-licked stone.
Some turn into starfish, five arms
fastening onto rocks below the tide.
The ocean and the sky shake hands,
collaborate to make the world
liquescent. As you dive down,
your lungs expand. How you love
the webbing between your toes,
your thicker skin, the beam
shooting from your forehead
powered by your radiant cetacean brain.

Genesis: Rainforest

God as Grizzly
created salmon first, five kinds
for the rivers, lakes and oceans
she had made. Next, the sedge,
tasty in its roots—a joy
for the herbivores to come—and after,
still famished from her work,
she crafted skunk cabbage,
doused it with her favorite scent,
then berry after berry after berry
to ripen in the sun and rain.

Did she conjure birds then, too,
long before she clawed in the trunks of trees
the blueprints for their bones?

With the might of her shoulders
from deep inside the earth
she hove the mountains into the sky,
dug out caves for dens, scratched runnels
in the rock for tumbling water.

No one knows how long
it took to raise the mountains,
or pin the stars one by one
above the peaks, but she made time
to design, for her own amusement,
a Great Bear constellation.

Tired then, with a yawn that sucked in
all the air above her head, she devised
the biggest sleep she could dream up
and filled her dreams with falling snow.

Before she rested, though, Grizzly
tweaked the salmon
so the ones who ventured far
would return to the rivers of their birth,
without number, without end,
like the trees she'd build tomorrow,
tall and greener than the rain.

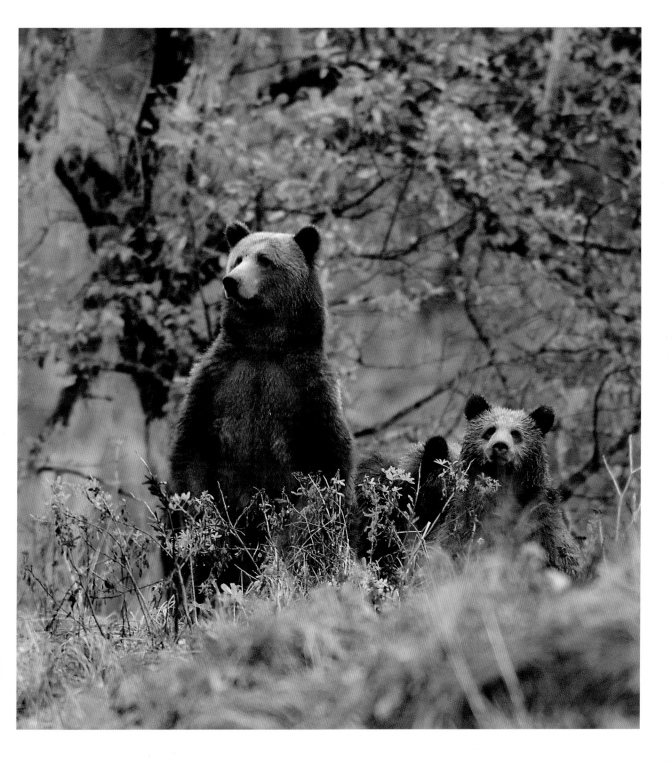

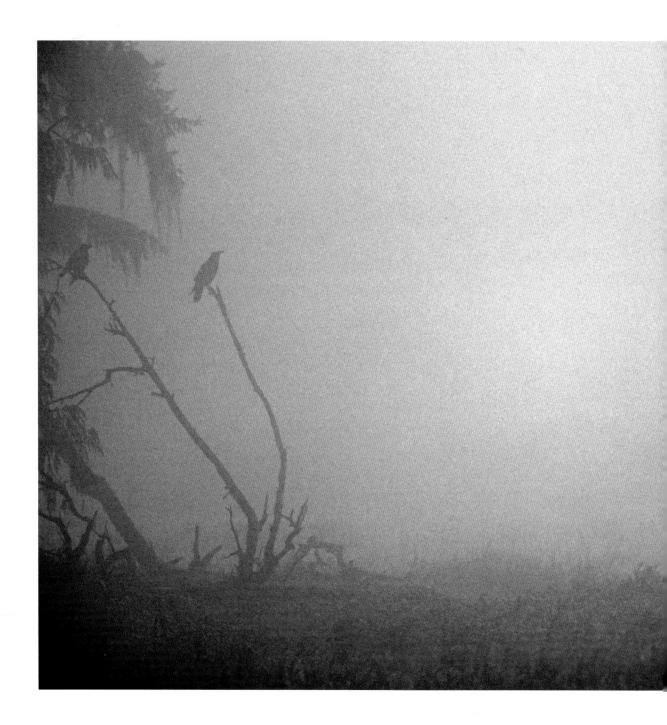

A Good Place

A forest draped
 with moss and mist—
a softness,
 a quietude—
a good place to send the soul.

Wolves

The wild in you has gone out
to meet the wolves who are hunting

on the other shore. You can't see
this wayward part of you

like you see your breath in winter,
but you feel the bite of canine teeth

as if you now live
in the throat of a panicked deer.

You've never understood before
what beauty means, how it

blasts the blood and leaves you
shaken, demanding more

than you can ever,
in this human body, be.

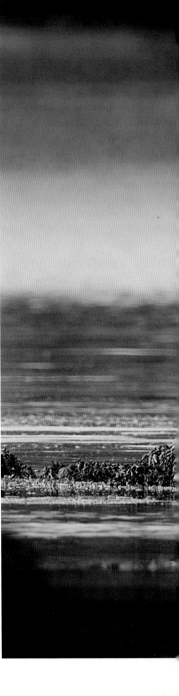

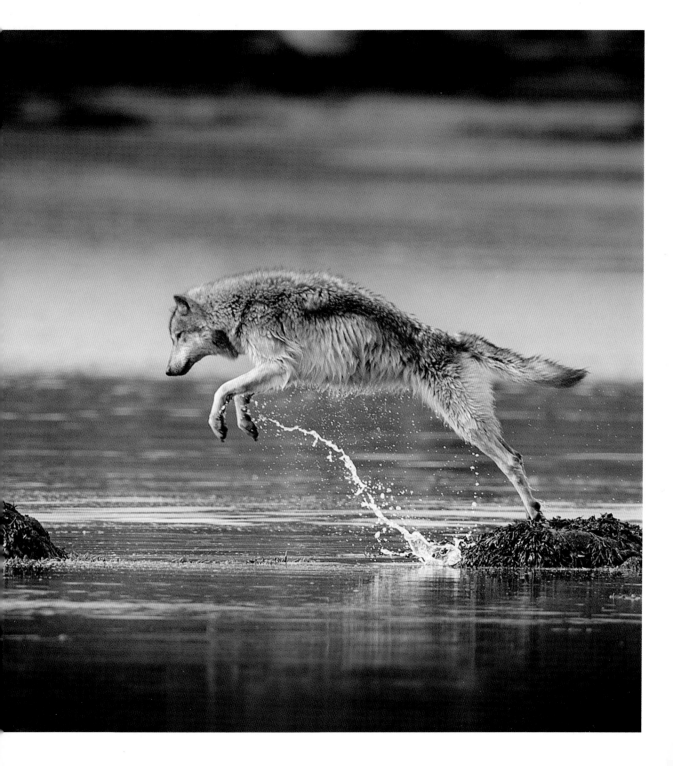

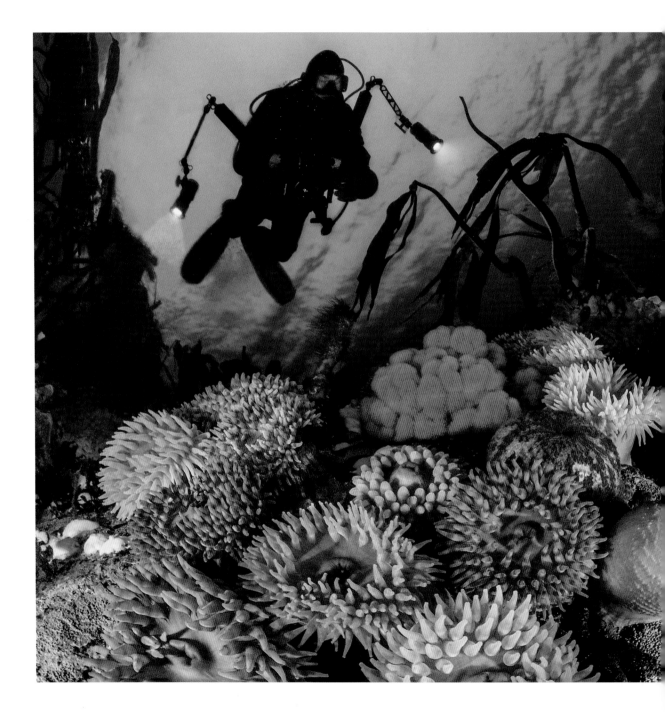

Gone Under

Among the fish you feel clumsy,
somnambulant, someone fallen,
perhaps from grace. You could beg
for mercy but who's to listen,
and anyway, more easily than
up above, the sea swings open
its pearly gates, no matter
what your sins or lack of them.
Baffled, gone under, you've been
hallowed with a halibut's
uncanny second sight,
its left eye having slid
to the same side as the right.

The Beauty of Opposites

A bear and a berry
so delicately balanced
on that huge tongue

like a sweet round vowel
from a miniaturist's
alphabet

that makes you go

o!

and means more than you
can ever say.

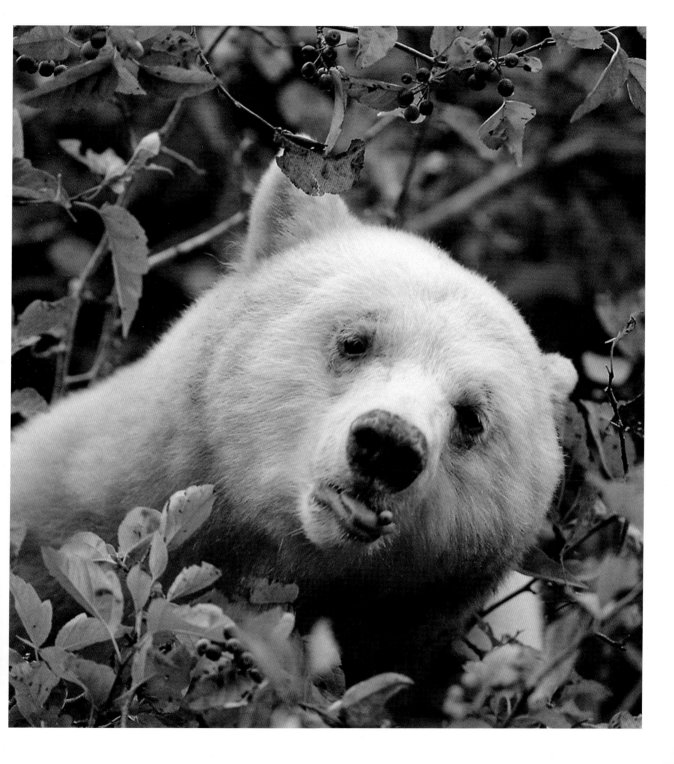

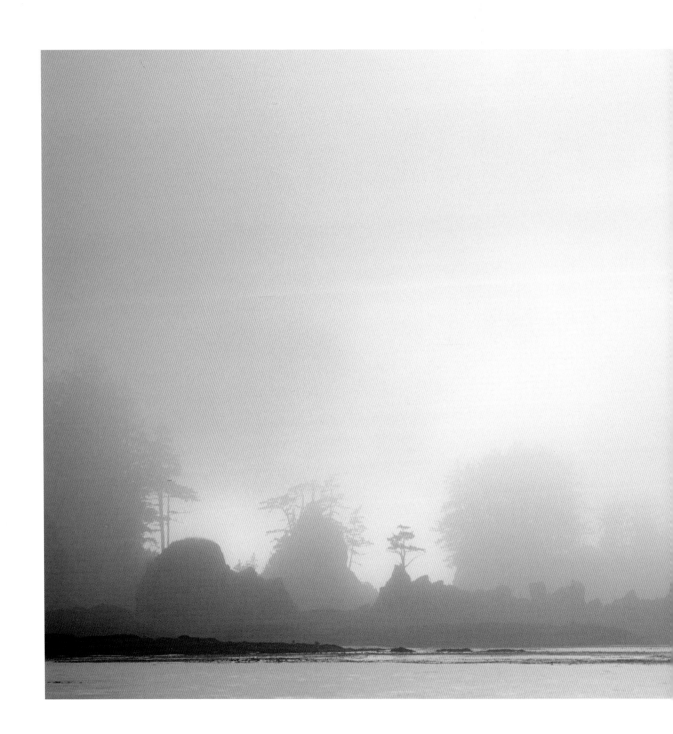

Photographer

What of the blind photographer?
The one who measures distance
by the warmth of the sun on her eyelids,
the one who hears the picture and snaps
that sound when you hear only silence,
the one who lists fourteen colors of the rain.

You imagine her cloaked and hooded
in a black cloth, a photographer from long ago
who grew images like lichen on glass and copper,
her fingers running over the plates
as if they spoke to her in Braille.

There are days when you blind yourself
with too much longing. Light is
tactile then. With its many hands
it washes the dullness
from your skin, touches all
that can't be seen and makes it glow.

Wonderland

To Alice's delight all the stars she'd wished upon
before she tumbled down the rabbit hole, now slumped
on rocks, exhausted from their fall into the sea.
"Curiouser and curiouser," she said out loud,
trying not to be afraid, but one of the starless rocks
turned its head and looked at her—a rock with eyes!
And then there were the hedgehogs without heads
or limbs, flowers that could swim, long eyes on stalks.
Below the tide, everything was more wondrous
than flamingo croquet bats or a pompous egg that talked.

"We're all mad here," said the Cheshire cat, meaning
there as well as here, and then he levitated, his orange
legs doubled into eight, each with suction cups. His grin
slid from his face and, suspended in the water, shimmered
like a string of shells turned inside out. She'd seen this before,
the cat's grin without the cat, but never the Cheshire's transformation—
legs—or were they arms—so dexterous, he picked
the rabbit's watch from her pocket and took it apart,
the little wheels spinning in the current
all that was left of time.

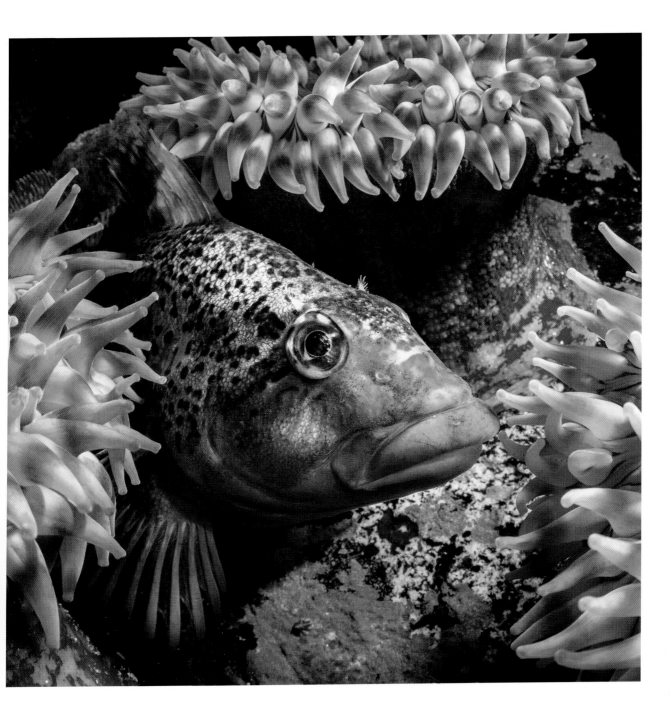

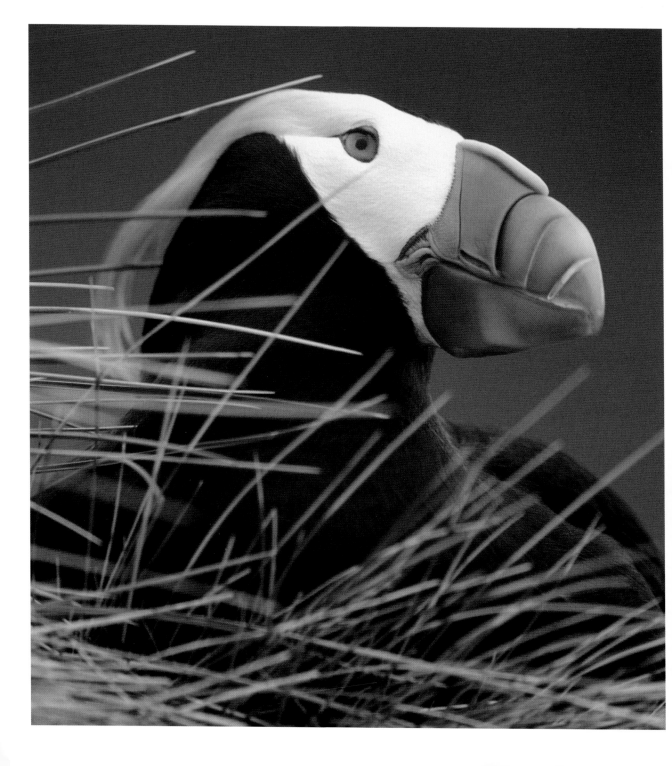

Puffin

In all this magnificence—
whales big as barns,
trees older than a country,
winds slashing across the ocean with horizontal scythes—
get serious, you could die here!—
there's a bird who looks like Groucho Marx.

With a beak like that, he can crack
a hundred jokes, bite off the tip
of a cigar. You expect a funny
wet-tux shuffle: torso bent low
to the ground, one wing crooked
to rest on the small of his back.

On clownish feet
he trundles as fast as he can
off the boulder's stage and out of sight
as if, to an audience of cackling gulls,
he's just insulted
the killer whale's wife.

Anemone

With water as its meadow,
water as its weather, water
as its ancient almanac,
the anemone, vegetating on a rock,
meditating, some would say,
decides to be a plant today—
something tropical, orchidaceous;
its fleshy, come-hither petals
might lure a lovely bird-like thing
that would sing, be soft with feathers
(though soaked, of course, in this
Neptunal garden) be sweetly edible,
digestible, and taste, the anemone
could only wish, of fish.

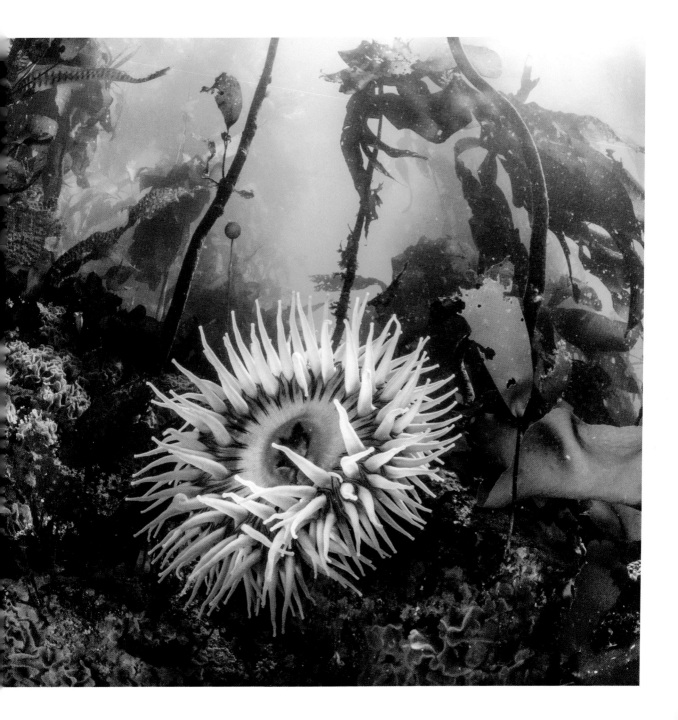

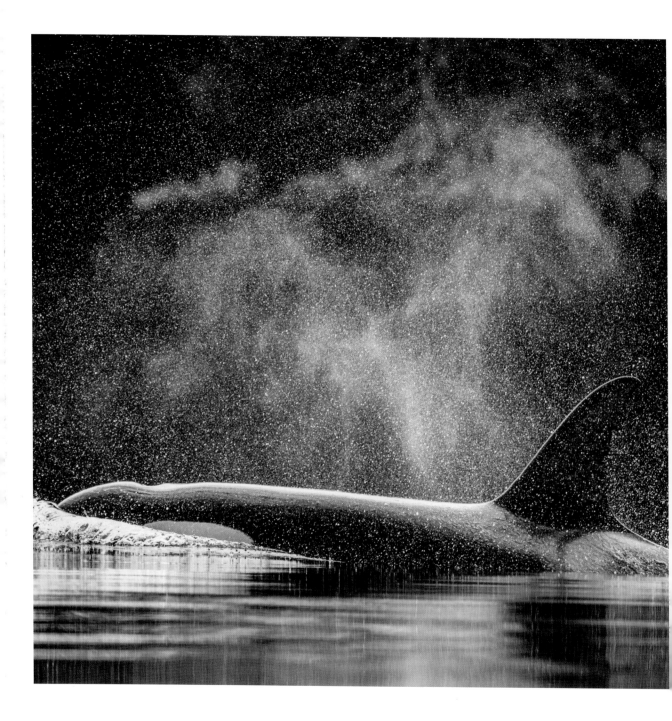

The Inspiration of Clouds

For days all the ocean could see
was clouds, how amazing their size,
their smooth slide across the sky
and the paps that hung below before a storm
as if milk would fill the hungry mouths
instead of rain. Inspired, the ocean fell
into a trance, mustered all the matter
it could find and made (how imaginative
it was, what ingenuity and flair!) the whales,
uncarapaced, heavier than thunderheads
but just as graceful, as far roaming, as thrilling
to behold. Bragging to anyone who'd listen,
the ocean claimed it fashioned whales
in its image, or to put it another way, if part
of itself had been granted heart and lungs,
mouth and tail, it would've chosen to be a whale—
there was that affinity to clouds, the ocean's muse,
but unlike them, unlike itself (and so dazzling,
so downright awe-inspiring) the whales could sing.

Sea Pen

SHAKESPEARE swept a sea pen across the page
and brought to life the beautiful Ophelia,
later, seeing in its strokes and sway,
her floral, soggy death.

IF POE HAD composed with a sea pen,
its orangey plume, he wouldn't have
been so dark. He'd have written
cormorant instead of *raven*,
its sleek head washed clean
of madness and monotony, as it dove
the "nevermore" croaked from its long throat
exploding into a gurgling—*dub doop
dubbo dee*—Satchmo scat.

FEDERICO García Lorca would've loved
the sea pen's frightened ink—if threatened
it emits a cold green light—for in the forest,
he claimed, he wrote in green
so the animals wouldn't be afraid.

MEANWHILE, the sea pen has its own poems—
it doesn't need another's genius. Unacquainted
with writer's block, it scrawls in the sand
what the ocean means to the Milky Way,
the water's moonwalk to the sleepy moon,
the cold pearls to the sailor's eyes.

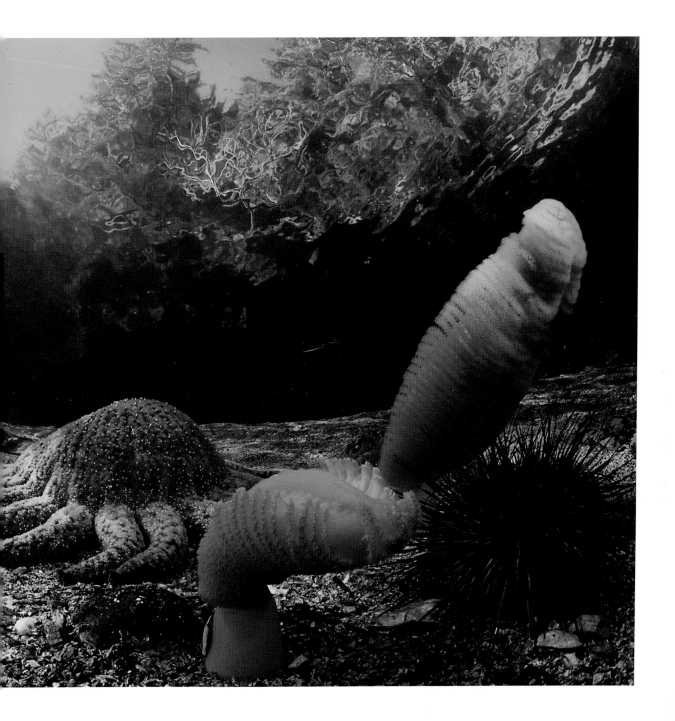

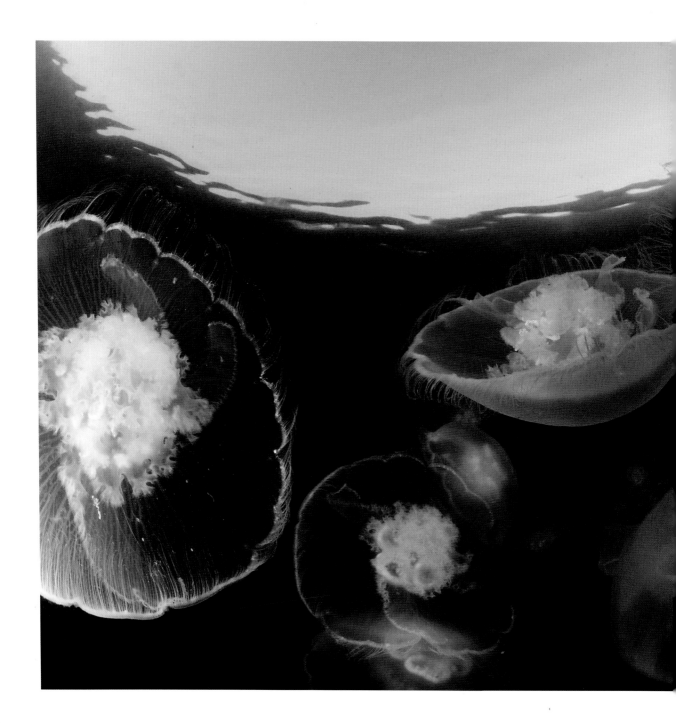

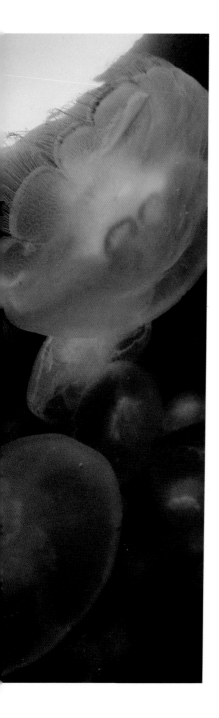

Jellyfish

I.
Cauls of the moon
pulled from the sky
at high tide, cauls from blue
newborn babies
who never had the chance
to breathe.

2.
Peeled like the thin
wrap of plums,
these are the curious
outer skins of brains
adapted to Atlantis,
their thinking so whimsical
and clear.

3.
See-through umbrellas
for the fanciful
and unaware,
they could swallow
your whole head
if you stood still
in what you thought
was rain.

Raven's Advice to Humans

The porpoise
doesn't need a purpose
like you do.

Its purpose
is to be a porpoise
and that's that.

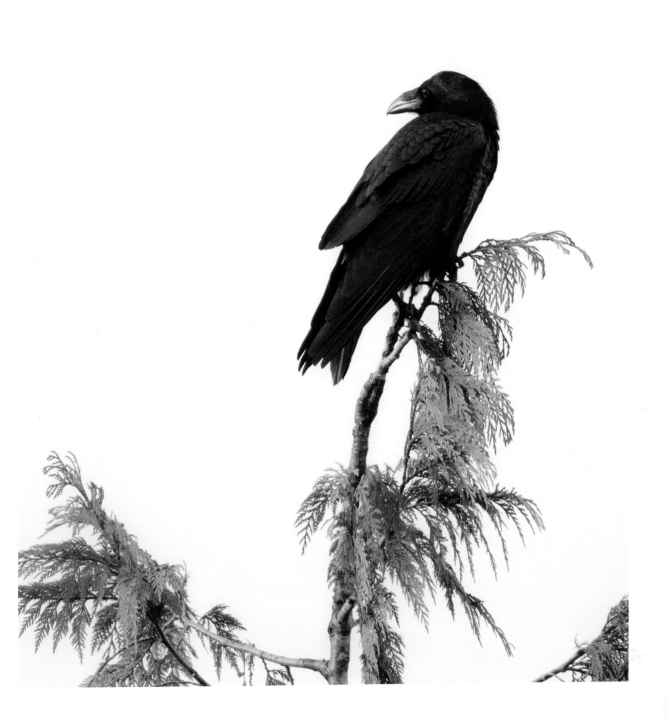

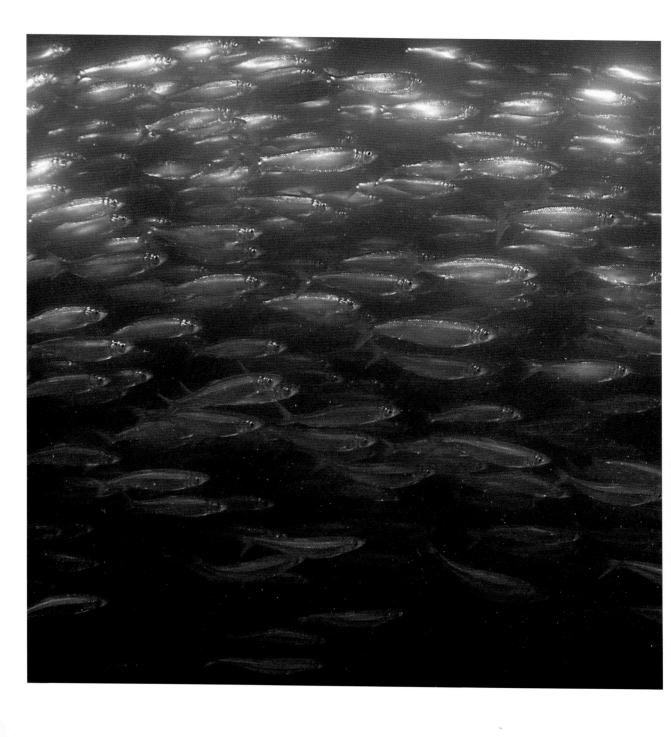

Herring

All the stars are fish.
All the light that once seduced your eyes
sits in the bellies of these fish.

From your bed you watch them float
high above where the ceiling should be.
They glide below where your feet
every morning touch the floor.

The door to your room is a blur of fish.
If you could reach it, you'd leave it closed
for fear of what might enter. Orcas, wolf
eels, sharks, the net of a drifter dropped
into a dream. The herring all around you

never touch, bump or falter:
one mind, merciless and lean,
pulls them forward, to the left, the right;
you, too, caught before you waken
in its slippery grip.

Who Watches Over You

Sea lions gather above you,
as nosey and dispassionate as angels
who catch sight of your tasks
small and far below
before they soar to a place more troubling
than where you are, at least for now.

Underwater, angels don't need feathers;
they don't need choirs or saints.
The sea lions, too, get by without them.

Ocean-thick, minus legs and wings,
they dive, climb, and wheel around you
as if, indeed, they are your keepers,
so close their whiskers graze your face.

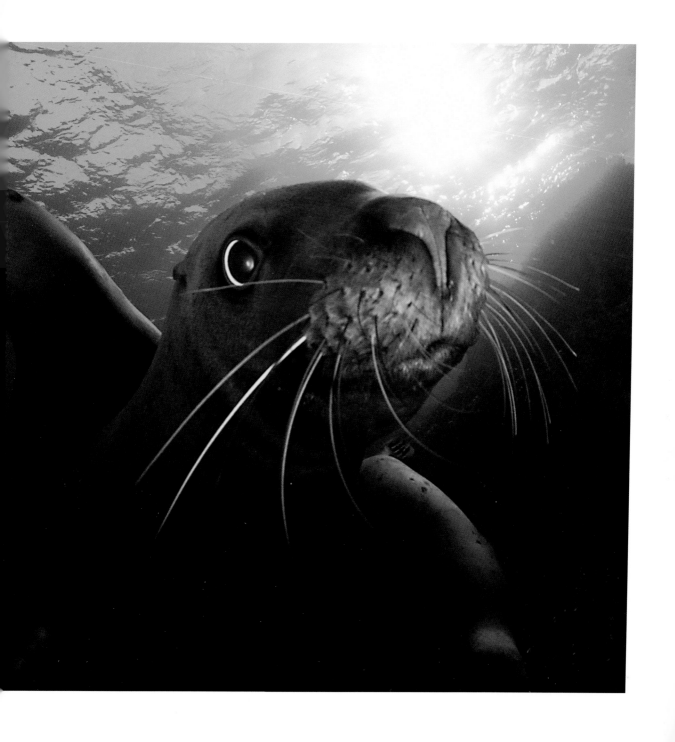

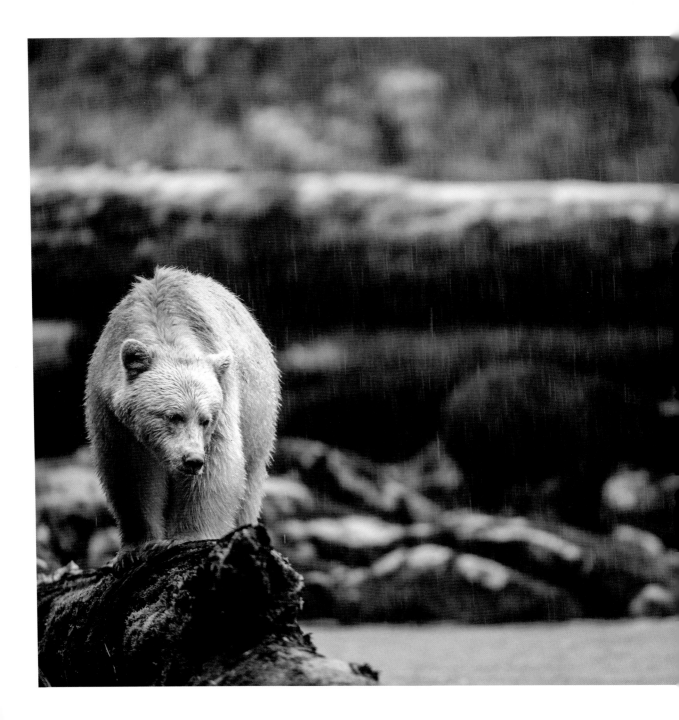

Spirit Bear, Ghost, Moon

If you see him, he's the opposite
of spirit. He looks all flesh, thick fur
steeped in rain. Weighted with gravity,
his paws sink deep trails through the forest
just like the grizzly and the black.

Though rare, the white bear's
no more miraculous than they,
or the Douglas fir, too old for counting,
or the herring who return only
when the moon tips toward the ocean,
the silver light it spills
a billion fish smacking the water.

All those who feed on herring
watch the moon, while you spend days
looking for a ghost whose brother
is the other side of night.

Maybe he's the moon's bear.
After the moon is emptied
and low in the sky, he climbs
inside its curve, rolls around
where the fish thrashed and splattered
and by morning, when he tumbles back to earth,
he's drenched with that smelly lunar light.

Photographer 2

Though you swear
you haven't budged
from behind the camera,
the lens catches something
you can't explain. After,
you glimpse yourself
inside the picture
like the artist who appears
in a corner of his painting,
in a mirror, perhaps, brush in hand,
or on a silver platter
in the glazed eye of a hare.

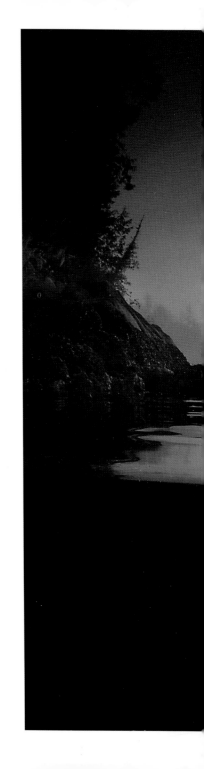

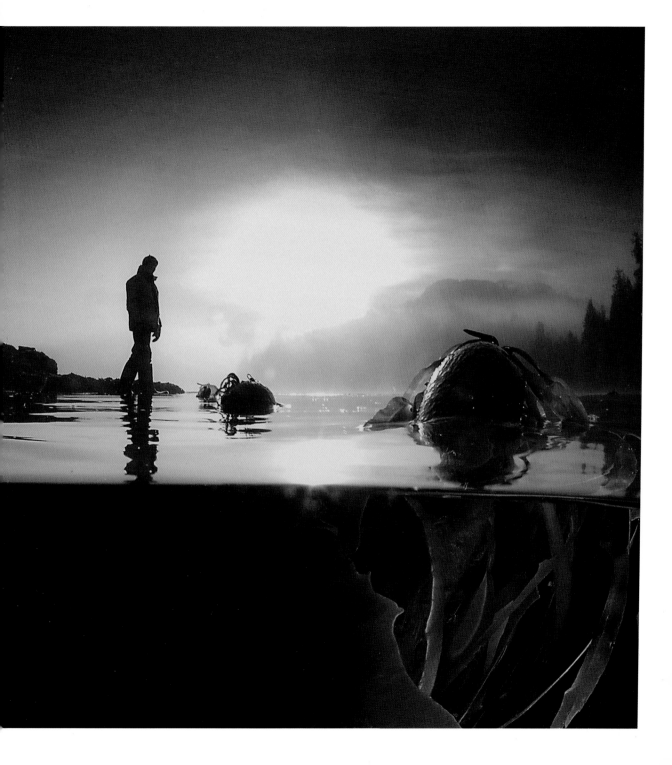

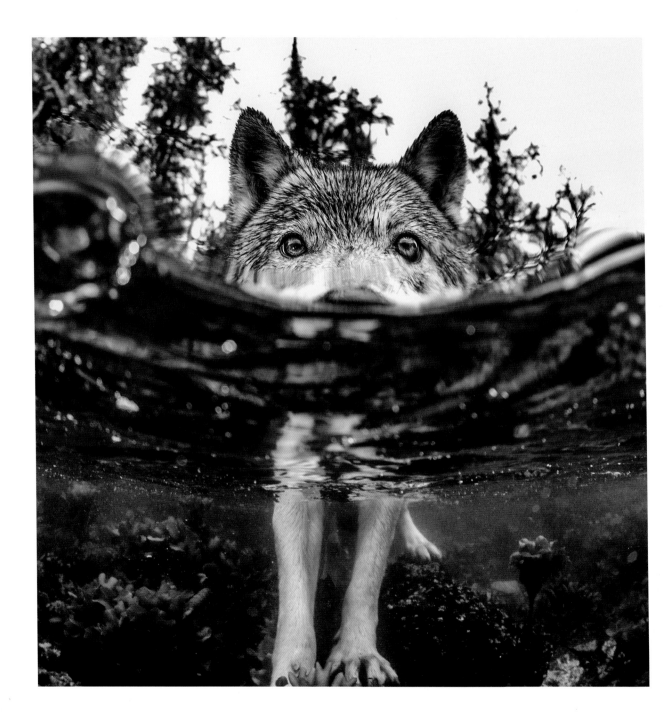

What Looks Back at
Her from Under the Water

Strange fish? Dolphin? Seal?
Cold black skin but it smells
like man and seems as clumsy,
as out of place, though she admires
its silence, its watchful eye.

Can she teach it
how to catch a herring as she's taught
her cubs, is it capable of such a thing?

What does it think? she wonders,
as it gazes back at her. Does it
have the wherewithal to read
the rivers and the wind?
Does it have a heart? She fears

it lives unlike her
without the warmth of family.
How sad each time she sees it,
no matter what the season,
it's alone.

Water Needed a Laugh

Water needed a laugh
 so it invented otters
to belly-slide, to tumble,
 to mischief around you
like cherubs
 gone bad.

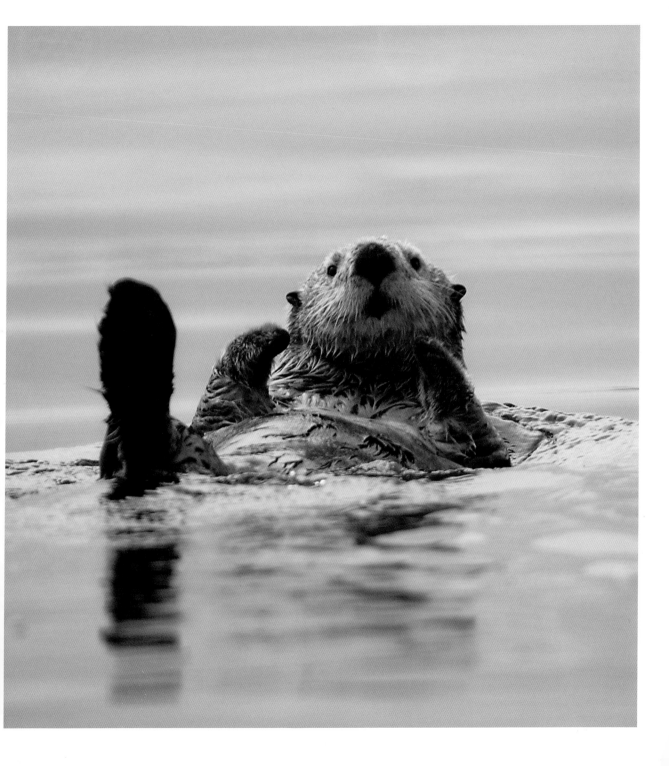

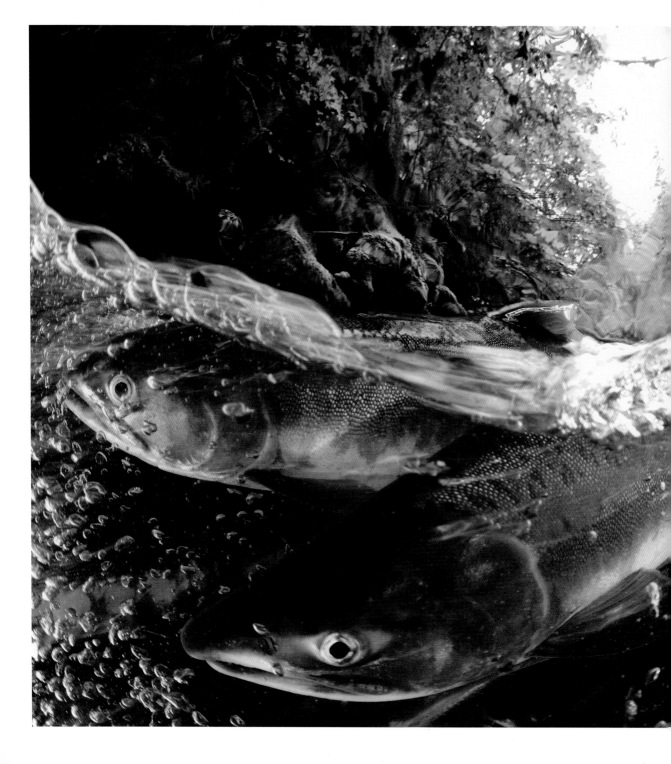

Dividing Lines

Here the membrane
between this and that
is thinner than a cat's
third eyelid, thinner than
a crane fly's wings.

At the edges, days and seasons blur—
watercolors blending on a page.

Rain erases the distinction
between brightness and the dark,
the ocean and the sky, a humpback
and the smallness you've become.

Like a hook baited with an egg,
birth catches death: salmon
traveling to their spawning beds
and their grimly beautiful decay.

Rain

A week of sun. Now the great spruce
sniff the air. Rain is coming from far off.
Their branches stretch to meet it; the sound
rain makes when it runnels down the bark
is song to them, melody and naming.
Sniff the air. What moves towards you,
what black clouds ride the wind,
unraveling? Stand tall to meet it, this
opposite of light, this dark shining.

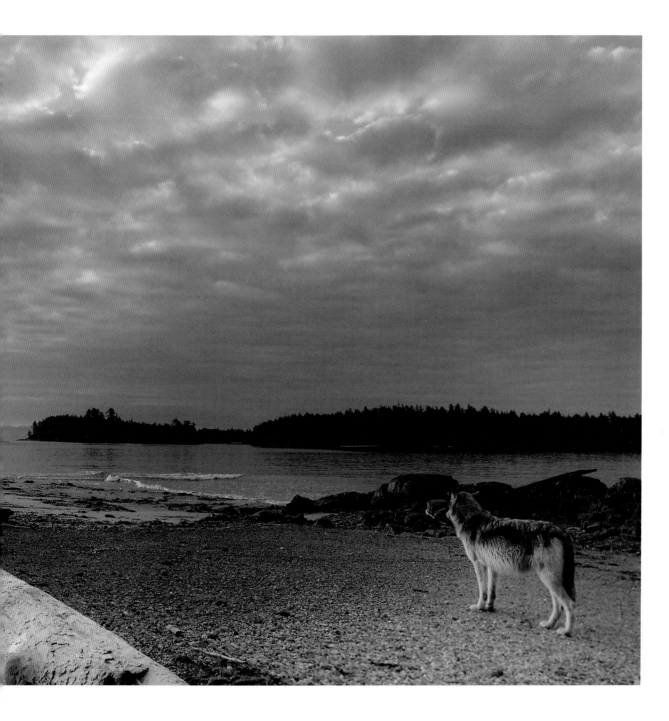

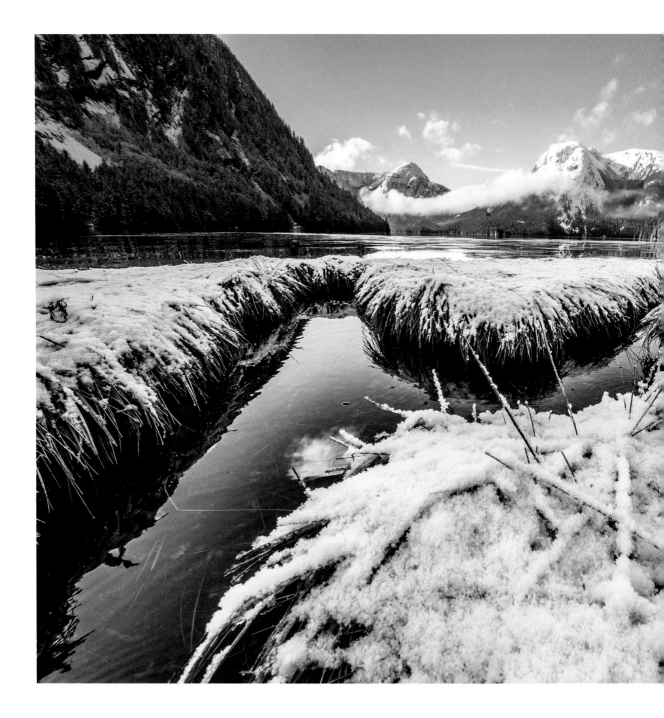

Winter

Water knows before you do
the coming of winter.
It starts to cool, hugs itself,
holds its breath. Feels
each cell turning crystal
as a larvae feels, under its skin,
the tremor of wings. Water's
ability to flow over stones
stalls. Like a dancer cursed,
frozen into place, it petrifies,
becomes a fierce, immobile
beauty that breaks.

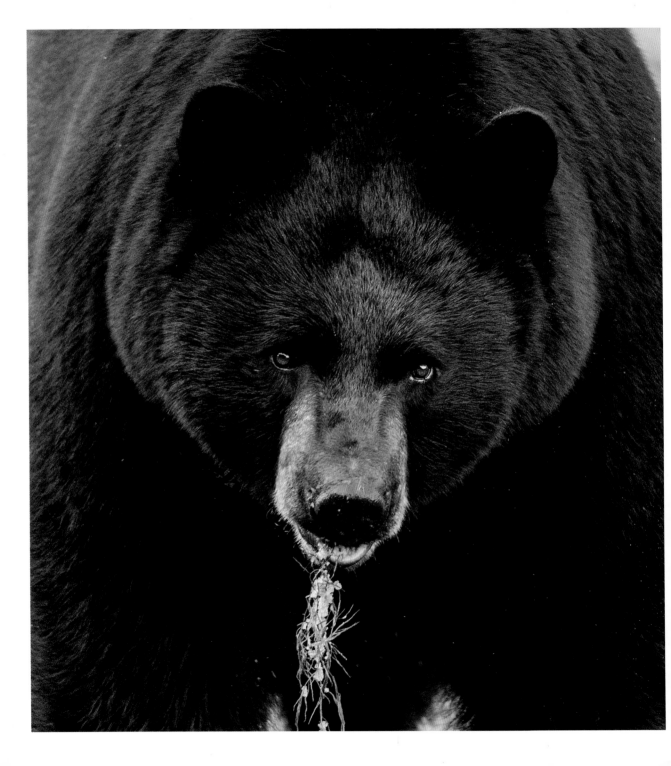

Being Seen

On the forest trail, a rabbit's
chewed-off foot, a torn wing
slick with spit, a Noh
choreography of bones.

Whatever watches from the shadows
can smell you now. Startled
from your body,
what you are inside
flinches in the naked light,
not wanting to be looked at.

Even now, you try to name
the prickly patch of flesh
on the back of your neck
under your hair. Being seen
has a skin: the air glistens with it.

What the Stone Sees

The stone on the floor of the ocean
has chosen to wear this face: eyes

that will not shut, a mouth that opens
or that's on its way to never

opening again. How starkly beautiful it is,
how locked in place, its own weight less than

the muscled hands of water
pressing down, the nose flattened.

It could be a small sun, doused and petrified—
it could be a mask of the sun

fallen when the sun came too close,
solar narcissus, always

drowning. The stone stares at you, it startles—
as if you've come upon your own face,

salt-worn and cold, older than anything
your blood knows.

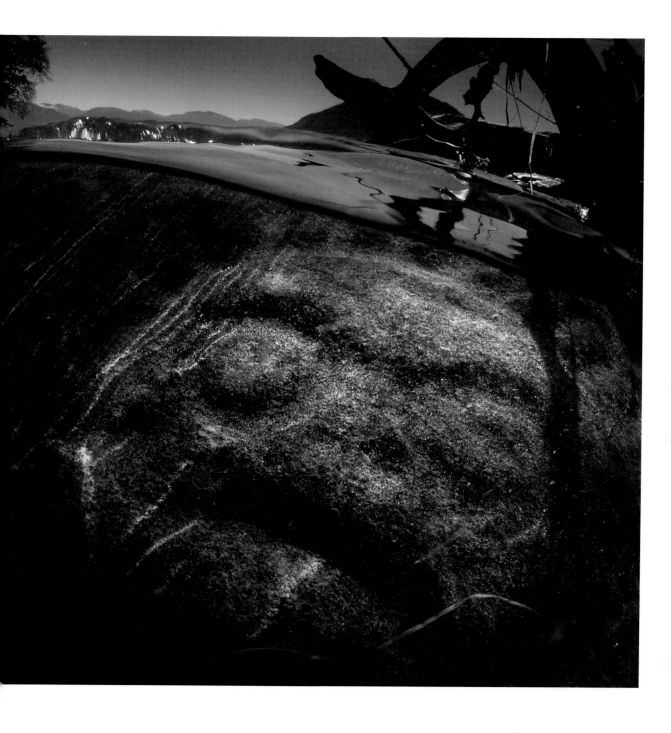

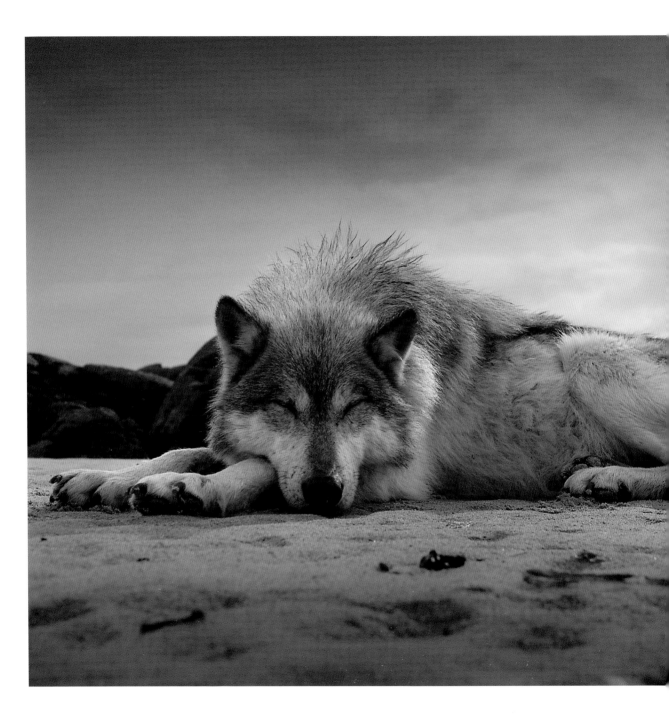

A Winter's Sleep

So much sleeping
in this place. Think of all
that lies beneath the snow, lake trout
below the ice, bears in their dens,
their warm snores drifting above
the tree tops that are sleeping, too,
high above your own long sleep.

Even raven, with so much
to say and do, closes his eyes,
tucks his beak under his wing
and sinks into the season's
dream-rich dark where all
his stories start.

Thoreau Said a Walk
Changes the Walker

A rainforest changes the man,
it changes the woman.
Some were born with rivers
in their blood. Their ancestors
spoke with raven and fox,
spoke with wolf and otter and black fish,
spoke with salmon and eagle and frog and heron.

You speak to them, too,
and they talk back. Sometimes
you're close to grasping what they say—
that's how the rainforest
changes you.

Today at dusk a bear
walks through the eye
of the camera.

The old ones claim
a man lives inside a bear;
you tell nobody
a bear lives inside a man.

There are weeks in the forest
when your whole body is
a word even you can't utter
but the trees, in their
deep listening,
hear.

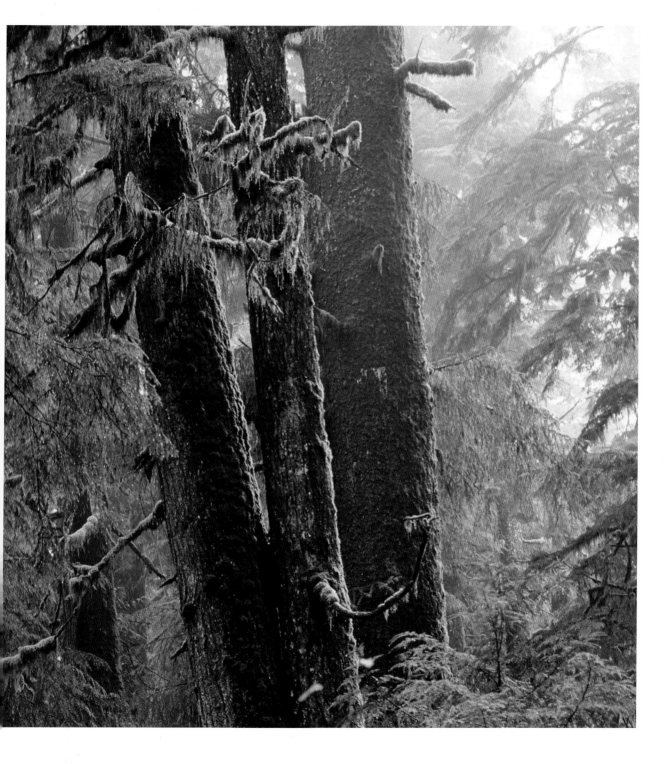

A Murder of Crows

A pod of whales.
An unkindness of ravens.
A gaze of raccoons, a skein of geese.
A sloth or sleuth of bears?

Sure, at the end of fall,
bears dig shallow bowls to plop
their fat bellies in
when they lie down to nap
and they love to nap,
but slothful? Sleuthful?

How about a burliness of bears,
a bulk of bears?
A balladry, a bedazzle,
a bamboozlement of bears,
a brouhaha! How about
a magnificence, a blessing of bears.

If we say *a blessing of bears*
over and over again
will we come to believe it?
Will we swear to do no harm?
Will we call the trophy hunters
what they really are? Try as we might,

we find nothing made of letters
to spell the evil that they do.

Bears haunt our sleep, bang without heads
into the walls of our nightmares, batting
the air with the stumps of their legs,
their paws gone.

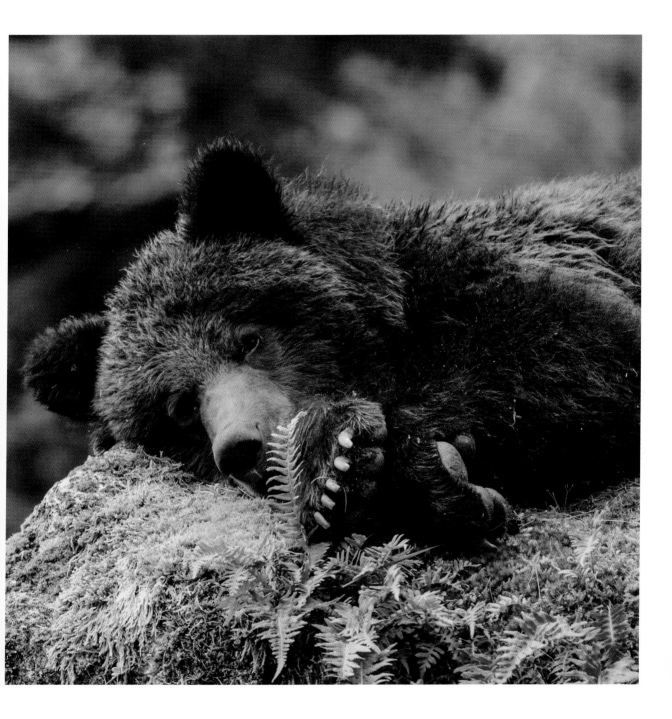

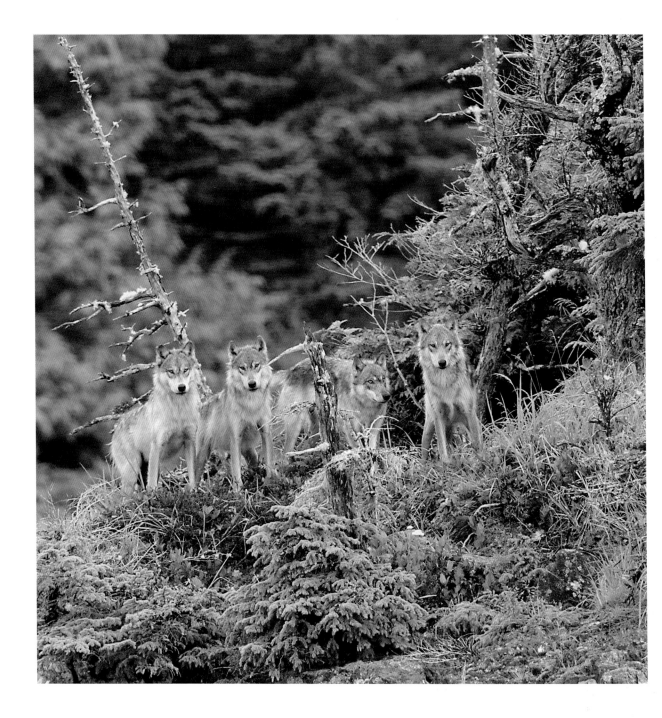

Photographer 3

What strange thing do you become
when you spend all this time alone,

watching? Your third eye is a camera.
Some days it's focused on a star

that's been dead a million years.
For a million years the animals

have followed the trails you shadow,
have hunted, played, raised their young

where you're now growing old. If you're lucky
they'll walk toward you, parting the hours

you've waited as if time were just another
kind of light. The camera sits at the center

of your breath. It knows your hands,
the weariness of your arms and shoulders.

When the animals draw near, there's too much
for the mind to hold. You've learned

to snuff your fear, to wait for the moment
when the heart starts thinking.

The Return

How did they know the slaughter had stopped?
The news traveled far across the ocean floor—*the whalers
are gone*—and the humpbacks began their journey home.

After twenty years away, only the oldest knew the smells,
the depths, the places of birth and feasting. Deeper
and wider than where they'd lived in exile, the silence
they remembered remains. It's quiet enough
for the teaching, for the calves and mothers to thrive.

This is a good story, the return of the humpbacks,
a story we like to tell, but the silence is dying,
the seas poisoned with noise. Tankers fracture
the whales' calls, hammer the herrings with clamor,
rip the fabric of dolphin dreams.

In all the whale dialects, when they speak of us,
they don't call us "humans," they don't call us
"woman" or "man." We are the-beings-
who-wound-the-waters, who-shatter-
the-ocean's-eardrums, who-blacken-its-lungs.

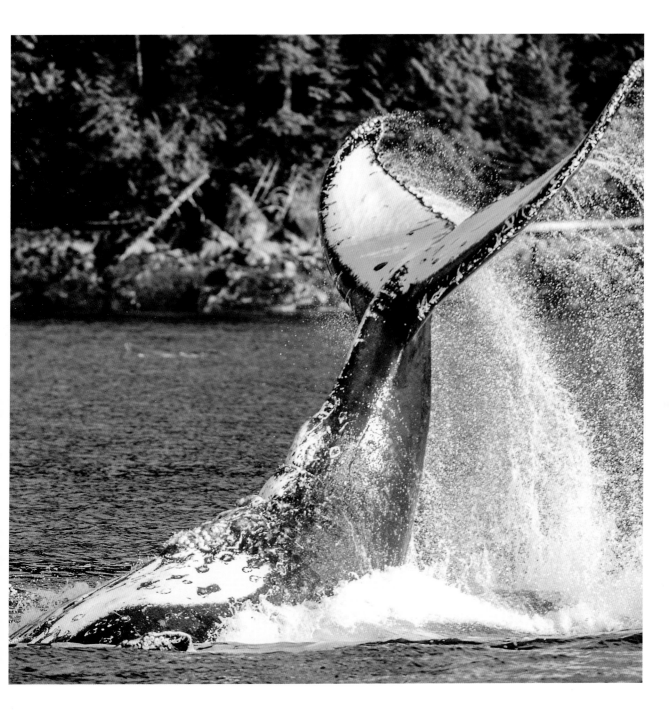

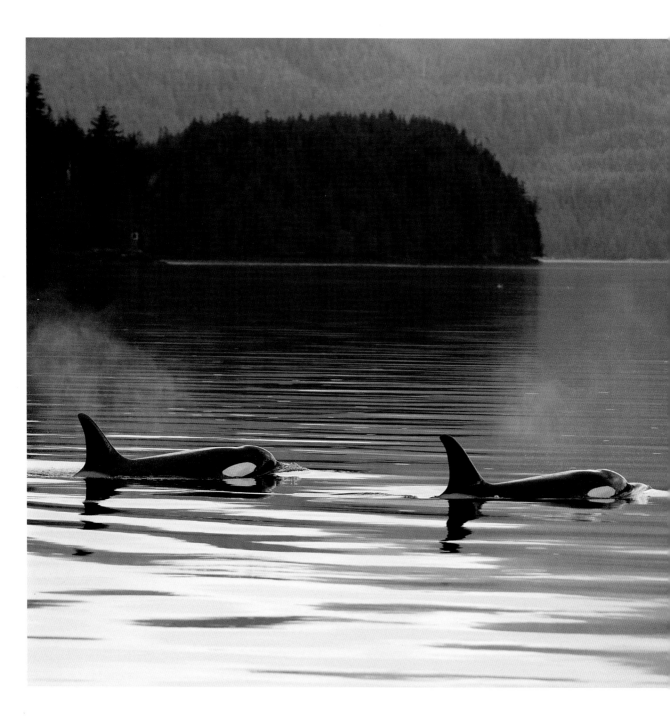

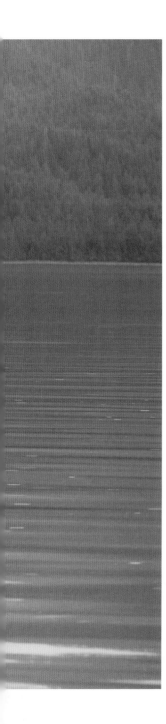

Northern Gateway

Once there was a mourning song
a singer sang for four days
staring out to sea. That song is lost.
Everyone born here, every old one,
every spirit the salmon feeds,
every man inside a bear, inside a whale,
inside the throat of frog and eagle,
every woman whose chopped hair
tossed into the sea, grew into eel grass,
whose wrist and ankle bones
became the pebbles
waves rattle on the shore, every child
raised by wolves, by mother cedars,
by sea lions in undertows of grief—
these are the ones called upon
to sing a lamentation that will not cease.
You don't want to hear that song.

Acknowledgments

With heartfelt thanks to Kim Gray at *Toque & Canoe* who set this collaboration into motion, and with respect to coastal First Nations whose traditional territories inspired these images and poems.

Thanks to Tim McGrady and the Kitasoo First Nation for hosting Lorna at Spirit Bear Lodge.

To Rob Sanders, Jennifer Croll and the rest of the staff at Greystone Books for ongoing support of both our work. Special thanks to Peter Cocking for designing this book and to Liz Philips for editing the poems. Thanks, too, to April Bencze at Pacific Wild for assistance with image management.

Both of us feel forever blessed and fortunate to be supported by our families.

THE DAVID SUZUKI INSTITUTE is a non-profit organization founded in 2010 to stimulate debate and action on environmental issues. The Institute and the David Suzuki Foundation both work to advance awareness of environmental issues important to all Canadians.

We invite you to support the activities of the Institute. For more information please contact us at:

David Suzuki Institute
219 – 2211 West 4th Avenue
Vancouver BC Canada V6K 4S2
info@davidsuzukiinstitute.org
604-742-2899
www.davidsuzukiinstitute.org

PACIFIC WILD is a non-profit organization and leading voice for wildlife conservation in Canada's Great Bear Rainforest. Innovative research, habitat protection, and public education remain cornerstones of Pacific Wild's approach to lasting environmental protection.

For more information on how to support Pacific Wild and the threats facing this globally unique ecosystem please contact:

Pacific Wild
PO Box 26
Denny Island BC Canada V0I 1B0
info@pacificwild.org
www.Pacificwild.org
www.facebook.com/Pacificwild.org

For the bears and the salmon, the trees and the wolves, and those who work to save them.

Greystone Books Ltd.
www.greystonebooks.com

David Suzuki Institute
219 – 2211 West 4th Avenue
Vancouver BC Canada V6K 4S2

Cataloguing data available from Library and Archives Canada
ISBN 978-1-77164-160-9 (cloth)
ISBN 978-1-77164-161-6 (epub)

Editing by Elizabeth Philips
Jacket and text design by Peter Cocking
Photography by Ian McAllister
Printed and bound in China by 1010 Printing International Ltd.
Distributed in the U.S. by Publishers Group West

We gratefully acknowledge the financial support of the Canada Council for the Arts, the British Columbia Arts Council, the Province of British Columbia through the Book Publishing Tax Credit, and the Government of Canada through the Canada Book Fund for our publishing activities.

Greystone Books is committed to reducing the consumption of old-growth forests in the books it publishes. This book is one step toward that goal.